Ms. Janes +

For all your time, energy,
inspiration, support, guidance,
spirit, strength, friendship,
listening, teaching, sharing
mentoring + You are
a remarkable person!

Thank You!

— Marilyn

To _Ms. Norma Janes_
 With Warmest Thanks

From _Marilyn K. Tanner_
 July 14, 2000

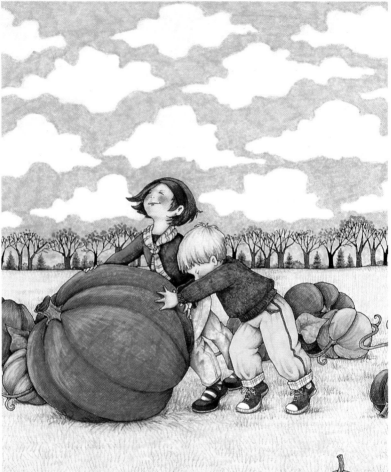

Thank You

Illustrated by
Mary Engelbreit

Andrews and McMeel
A Universal Press Syndicate Company
Kansas City

 is a registered trademark of Mary Engelbreit Enterprises, Inc.

10 9

ISBN: 0-8362-4610-1

Written by Jan Miller Girando

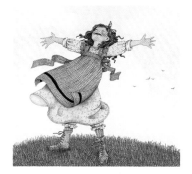

Thank You

Gratitude's a memory
that is held within the heart
and treasured more
with every passing year . . .

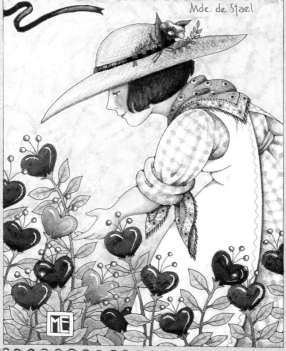

SOW GOOD SERVICES; SWEET REMEMBRANCES WILL GROW FROM THEM.

Mde. de Stael

. . . a memory of a kindness
or a special favor done
by someone who is held
especially dear.

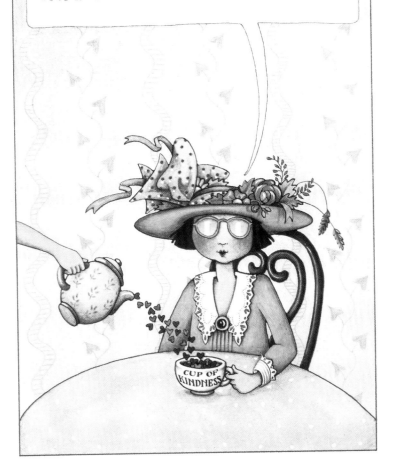

There's gratitude for memories
of celebrations shared . . .

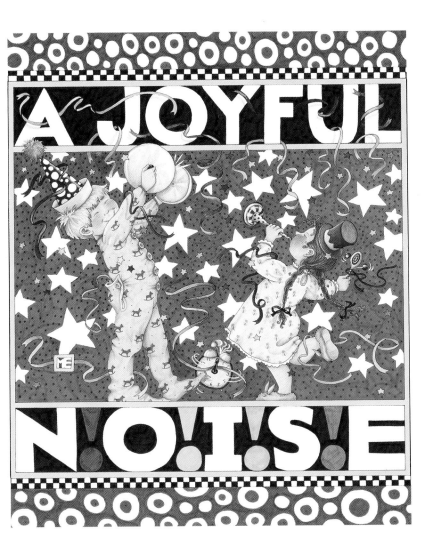

. . . for times somebody
went the extra mile . . .

THAT'S WHAT FRIENDS ARE FOR.

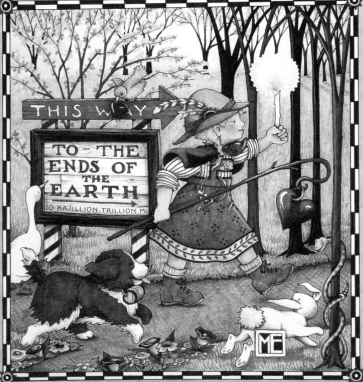

THIS WAY

TO THE
ENDS OF
THE
EARTH

10 KAJILLION TRILLION MI.

. . . and always for a welcomed word
of comfort and support . . .

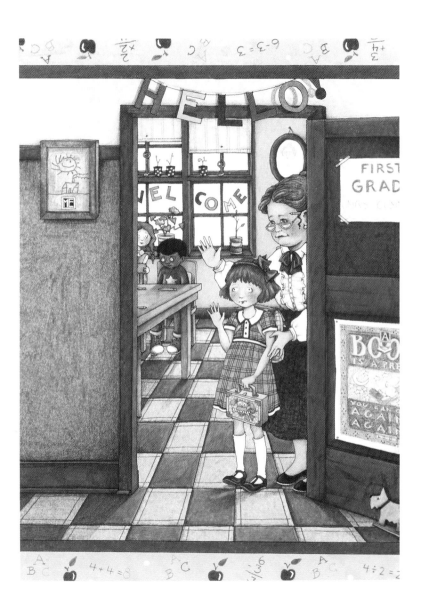

. . . that cheered a day
and brightened up a smile.

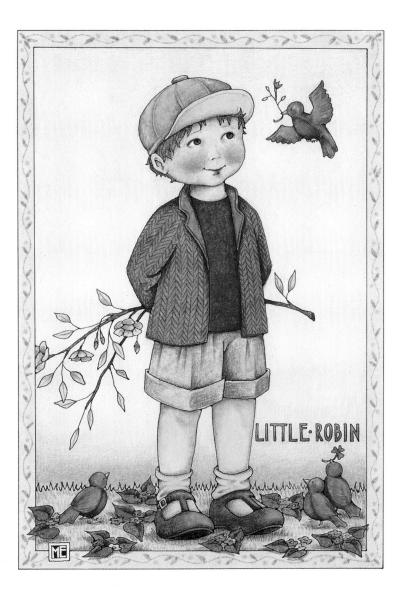

LITTLE·ROBIN

There's gratitude for disagreements
quickly overcome . . .

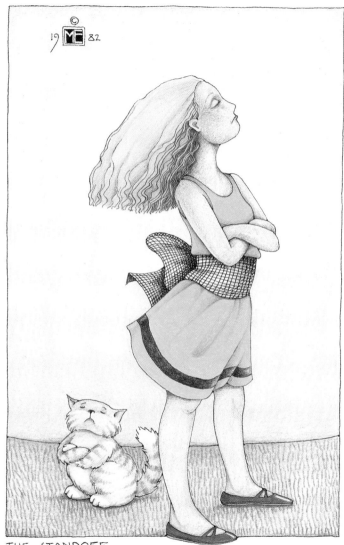

THE STANDOFF

. . . for colleagues who are staunchly
on our side . . .

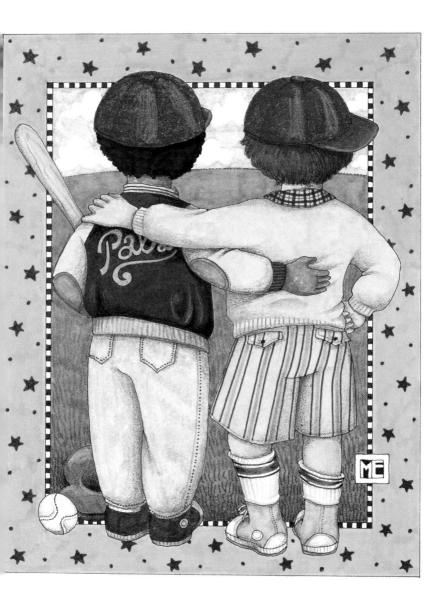

. . . for moments
of encouragement . . .

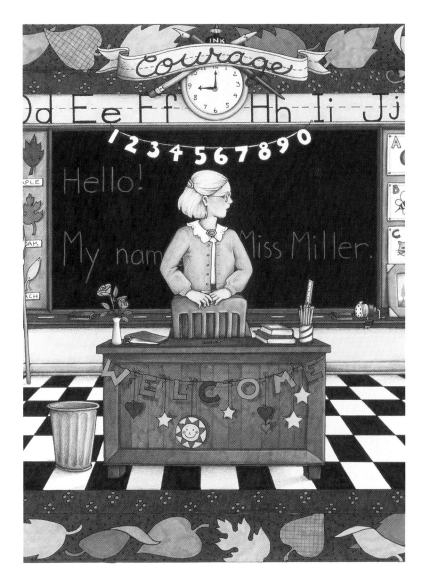

. . . for unexpected notes . . .

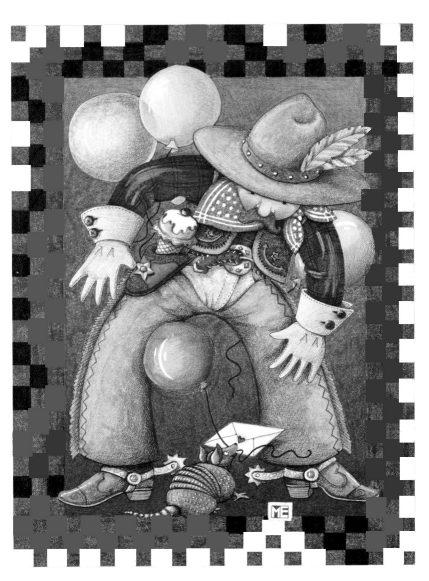

. . . for special friends
in whom we can confide.

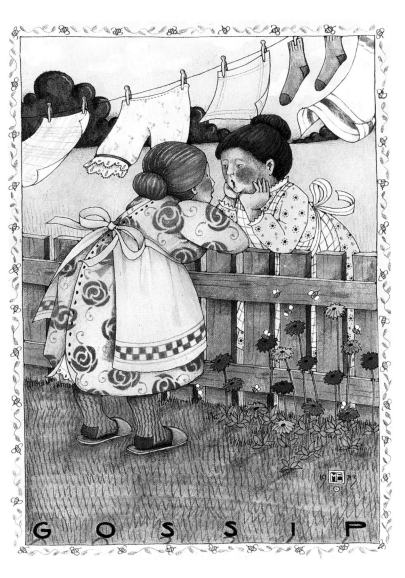

GOSSIP

Gratitude's a feeling
that's so often unexpressed,
and this is just the opportunity . . .

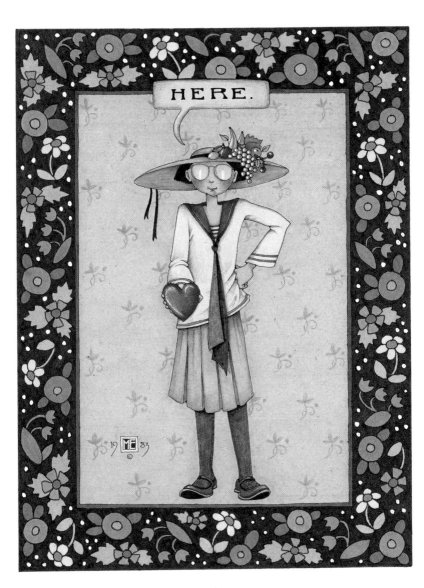

. . . to offer you
the warmest thanks
a heart could ever hold
for every lovely,
lasting memory.

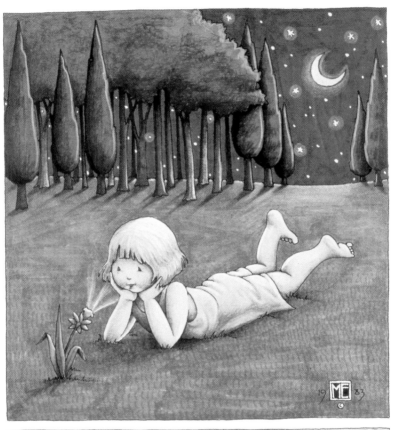

It is only with the heart that one can see rightly; What is essential is invisible to the eye.

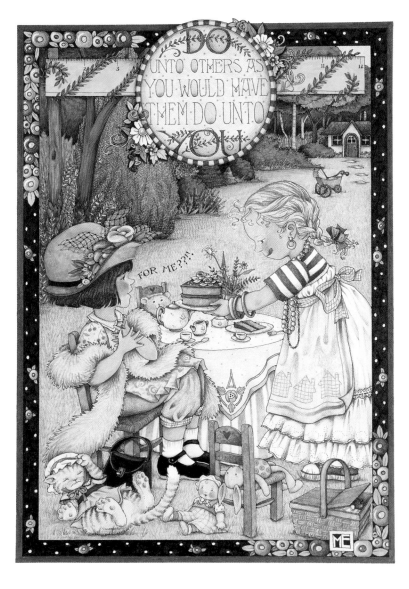